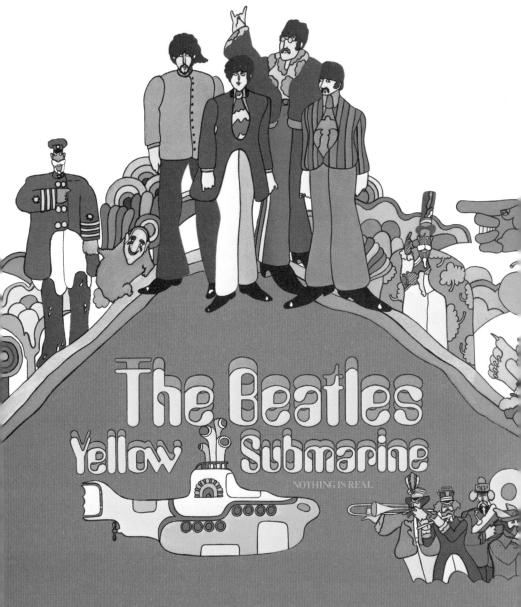

© 2024 Subafilms Ltd, A Yellow Submarine™ Product, ™ Trade

Mark of Subafilms Ltd © 1968, Authorised BEATLES™ Merchandise.

INSIGHTS

insighteditions.com

MANUFACTURED IN CHINA

10 9 8 7 6 5 4 3 2 1

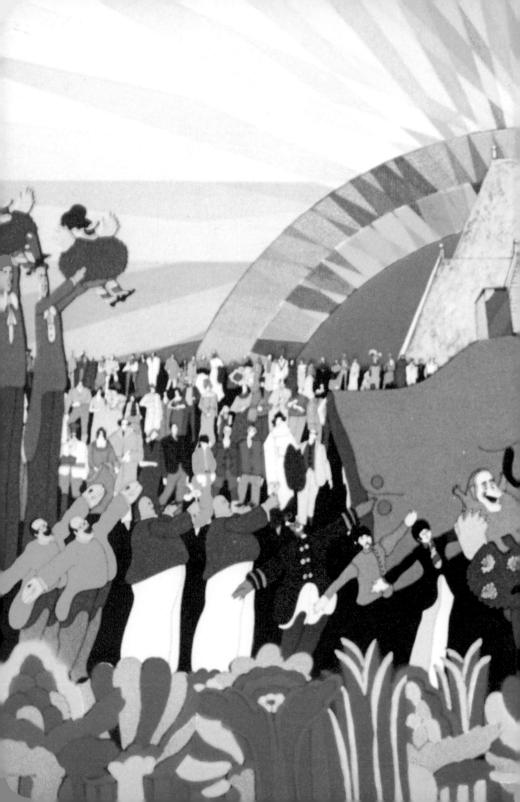